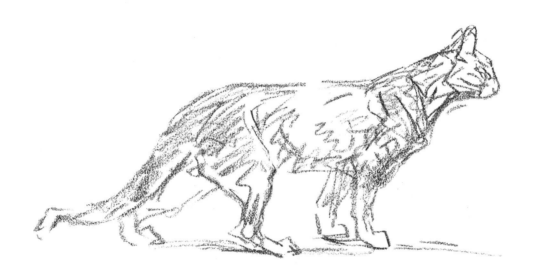

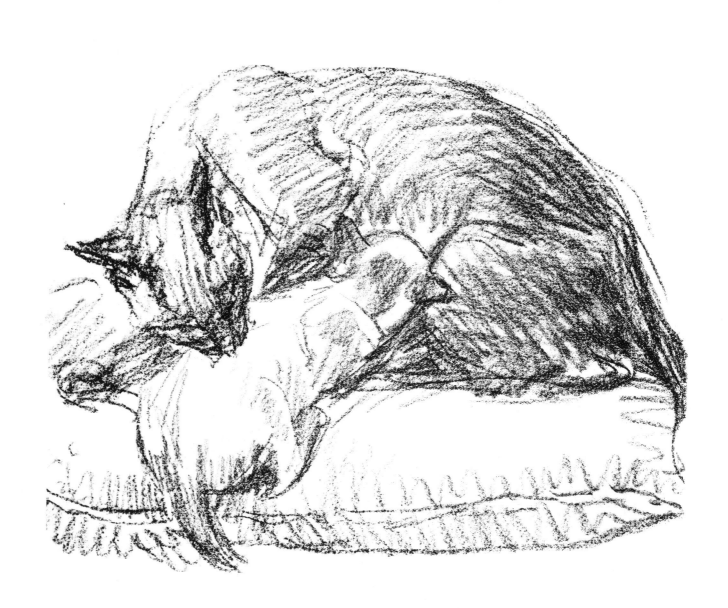

STEINLEN CATS

Drawings by
Théophile-Alexandre Steinlen

Dover Publications, Inc., New York

PUBLISHER'S NOTE

Théophile-Alexandre Steinlen (1859–1923), one of the greatest illustrators of the late nineteenth and early twentieth centuries, was born in Lausanne, Switzerland, but moved permanently to Paris at the age of 23 and became a French citizen.

In addition to posters, song sheets, etchings, murals and book illustrations, Steinlen did drawings for over 30 magazines, some of which he founded. A politically liberal Montmartre bohemian, he faithfully portrayed all aspects of Parisian life, but gave special attention to the everyday joys and sorrows of working people.

Perhaps no other sector of Steinlen's art is as strongly associated with his name today as his studies of cats. He never ceased to draw them in all their activities and moods. Cats figure prominently in some of his most famous works, such as his great poster "Pure Sterilized Milk from the Vingeanne."

The cat drawings in the present volume are reproduced from two rare volumes: a 1933 collection of previously unpublished animal drawings (*Chats et autres bêtes*, published in an edition of only 545 copies), and a turn-of-the-century album of picture stories without words (*Des chats*).

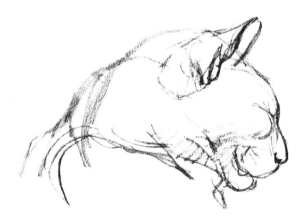

Published in Canada by General Publishing Company, Ltd., 30 Lesmill Road, Don Mills, Toronto, Ontario.
Published in the United Kingdom by Constable and Company, Ltd.

Steinlen's Cats, first published by Dover Publications, Inc., in 1980, is a new selection of drawings from the following two works:
Steinlen, *Chats et autres bêtes; dessins inédits*, Eugène Rey, Paris, 1933 (edition of 545 copies).
Steinlen, *Des chats; images sans paroles*, Ernest Flammarion, Paris, n.d.

International Standard Book Number: 0-486-23950-0
Library of Congress Catalog Card Number: 79-54990

Manufactured in the United States of America
Dover Publications, Inc.
180 Varick Street
New York, N.Y. 10014

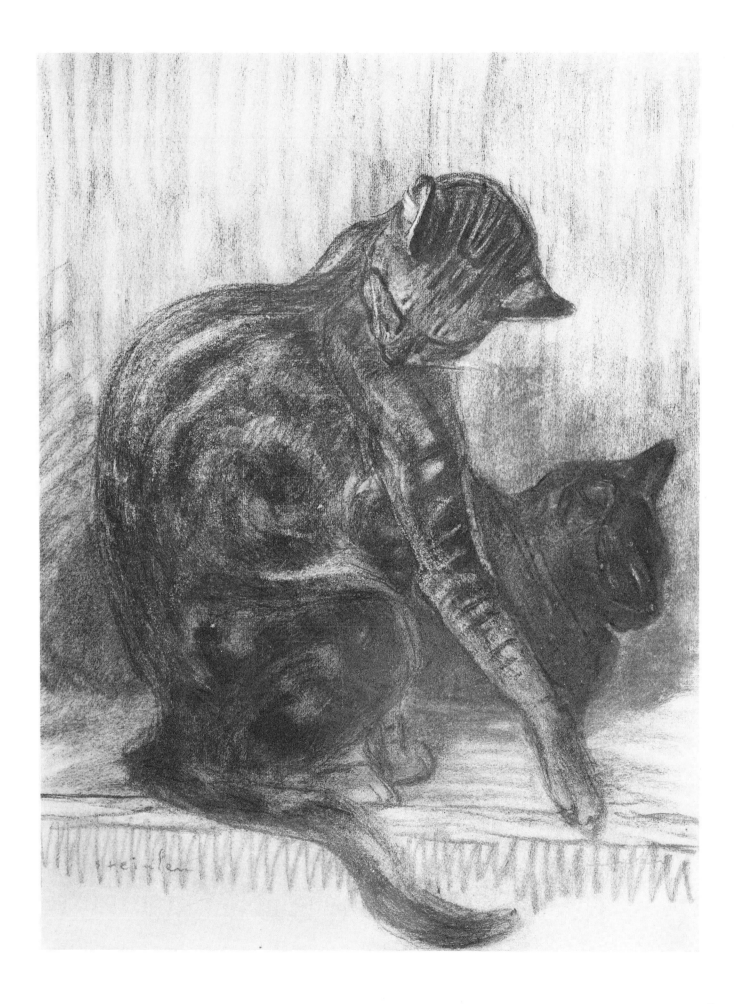

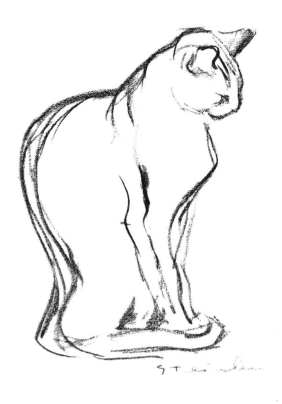

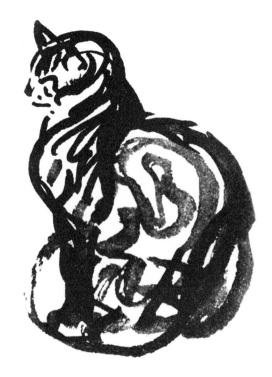

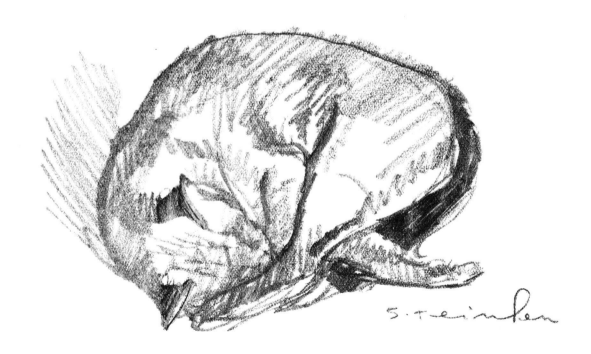

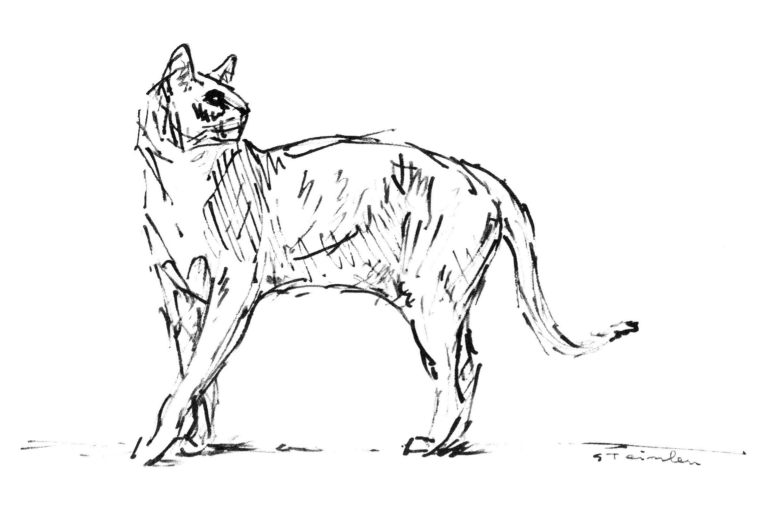

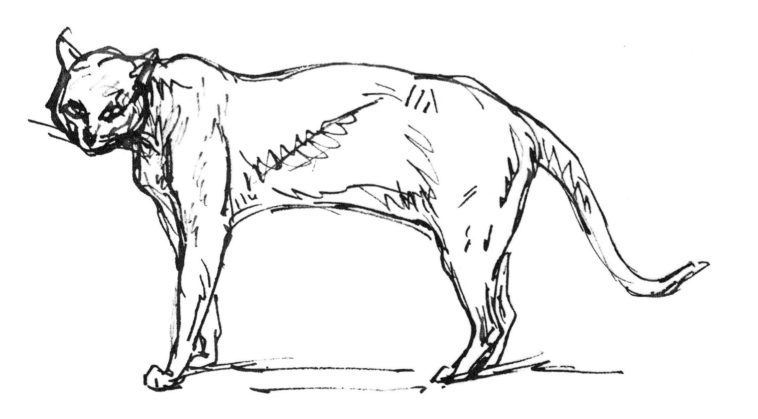

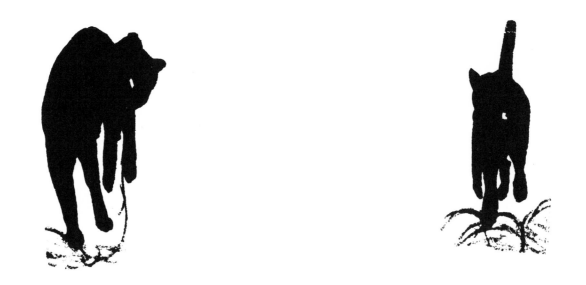

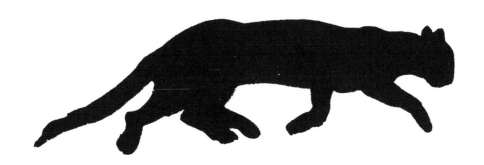

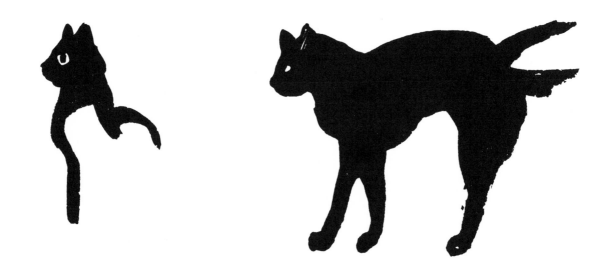

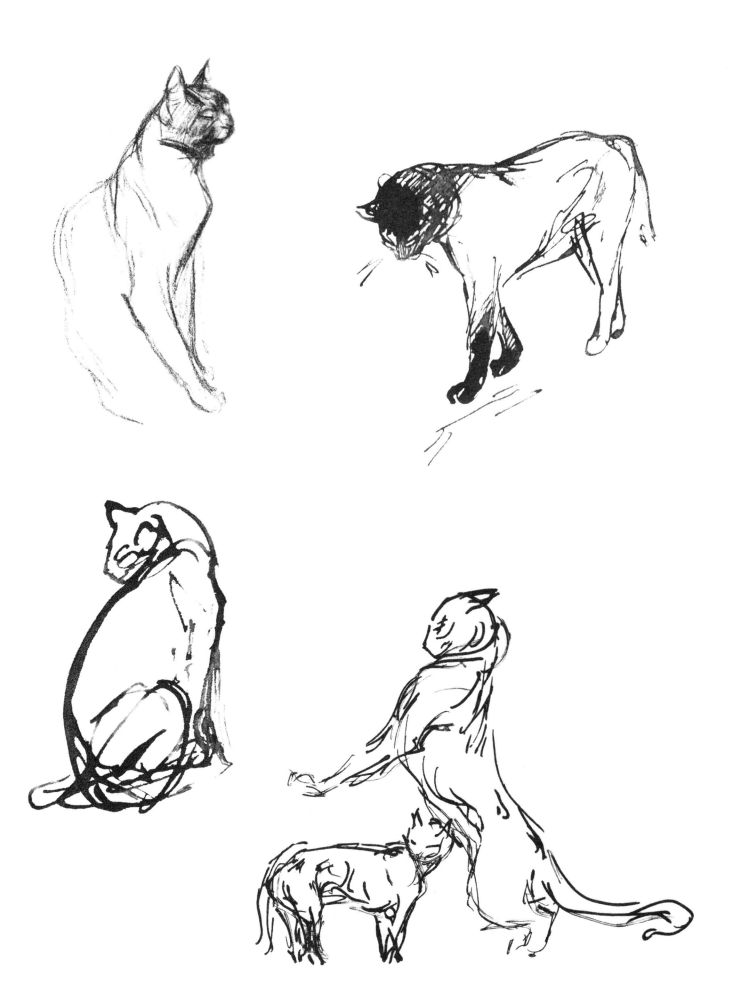

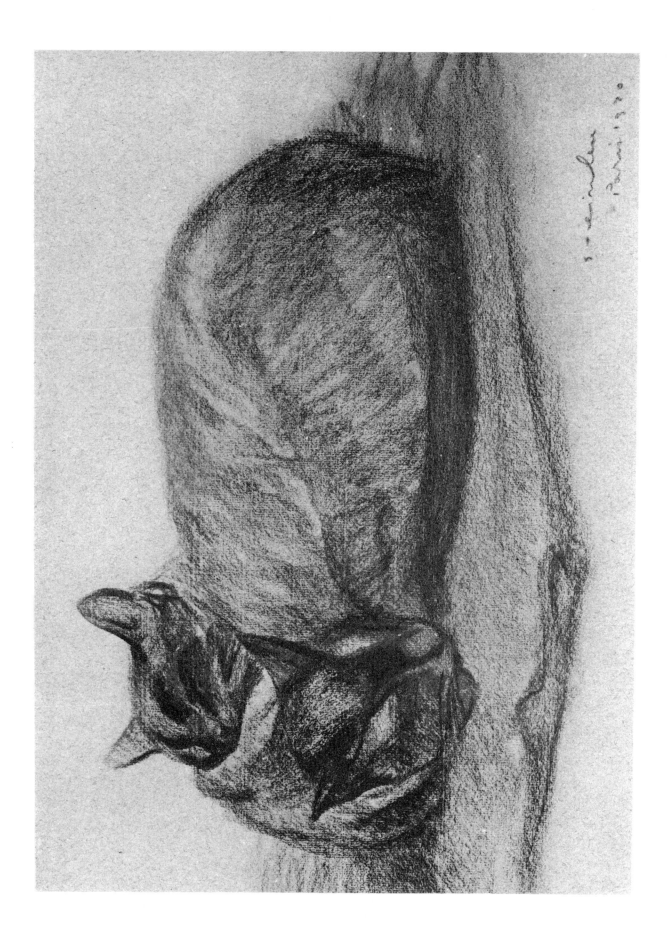

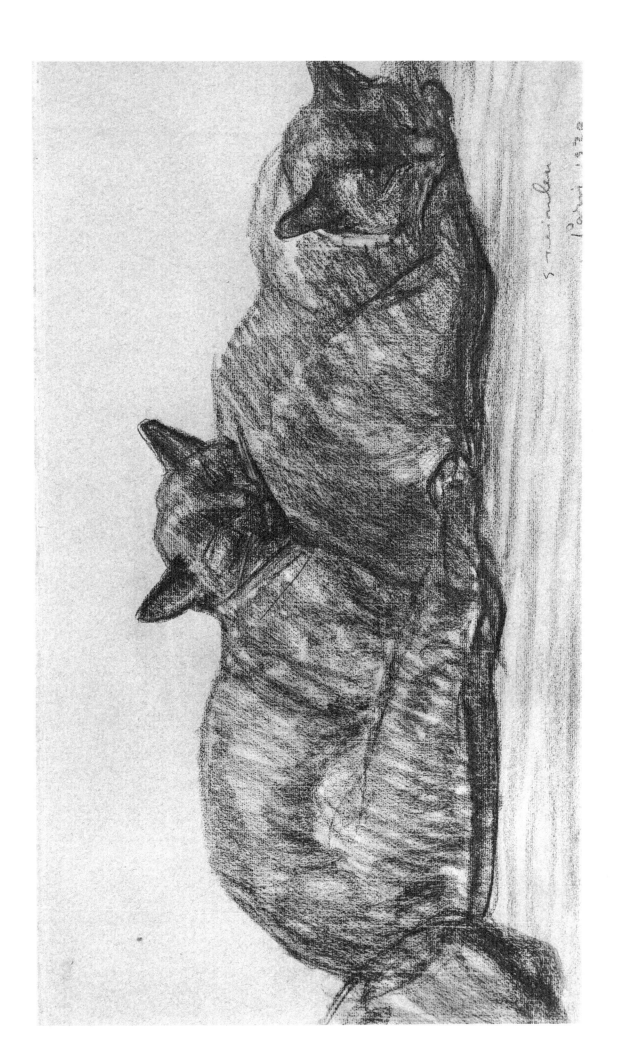

Steinlen
Paris 1902

7

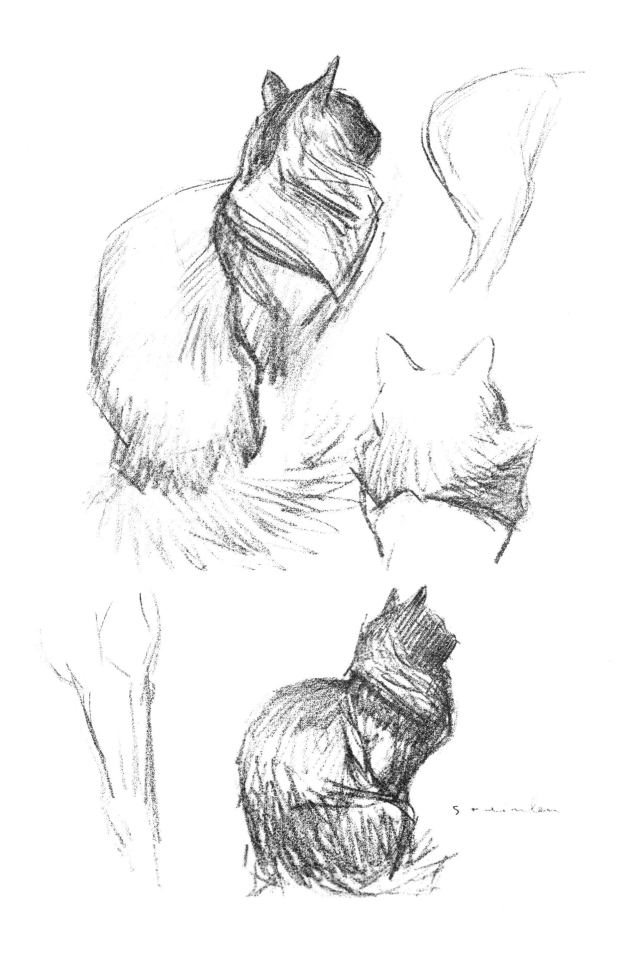

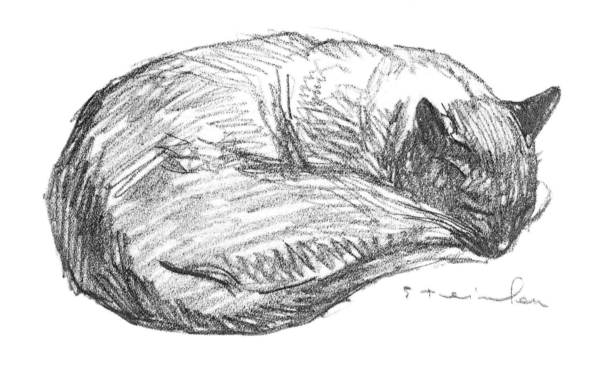

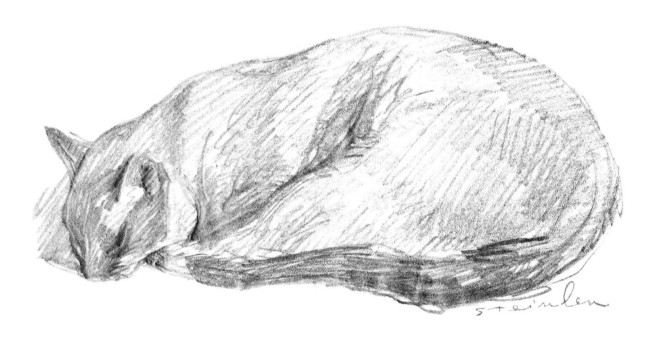

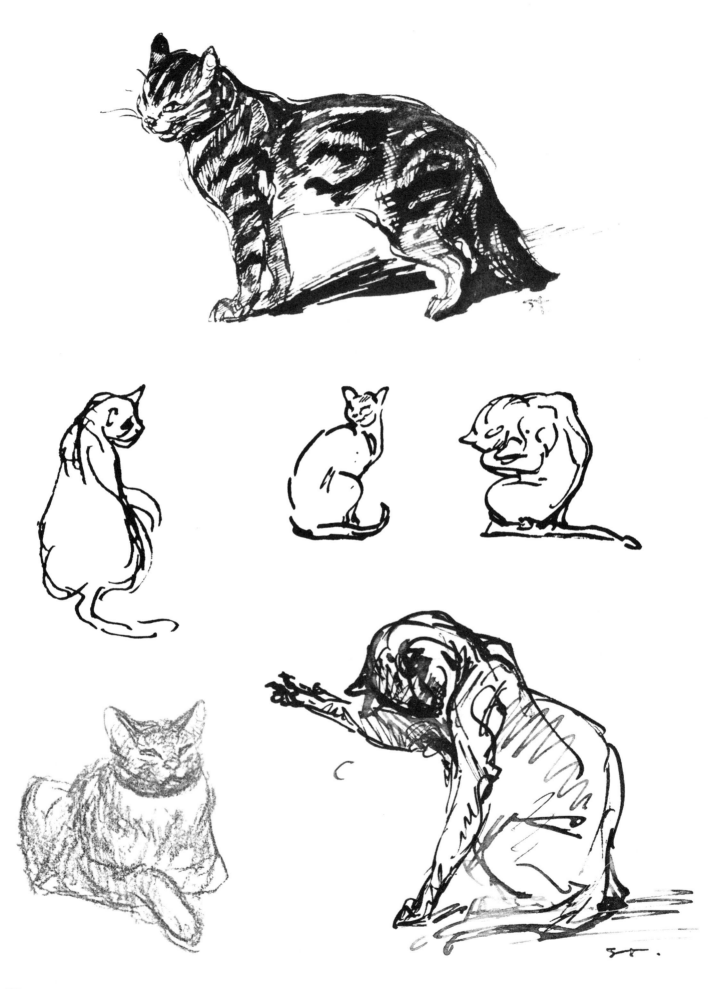

10

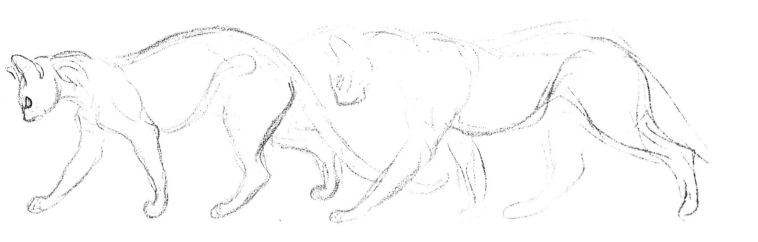

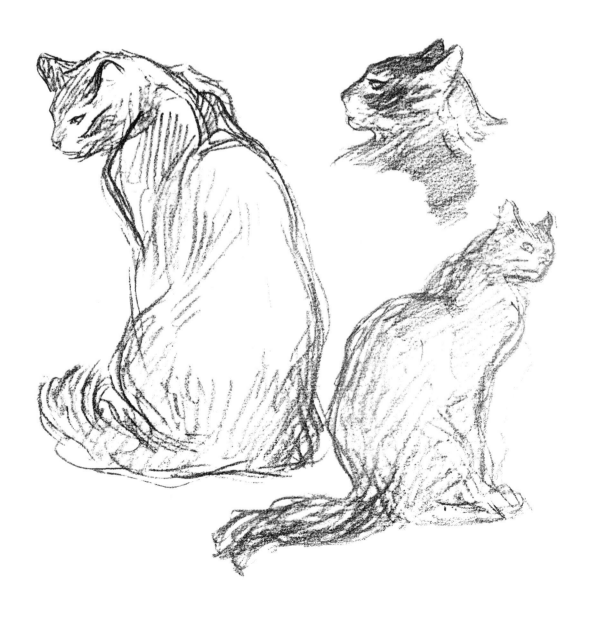

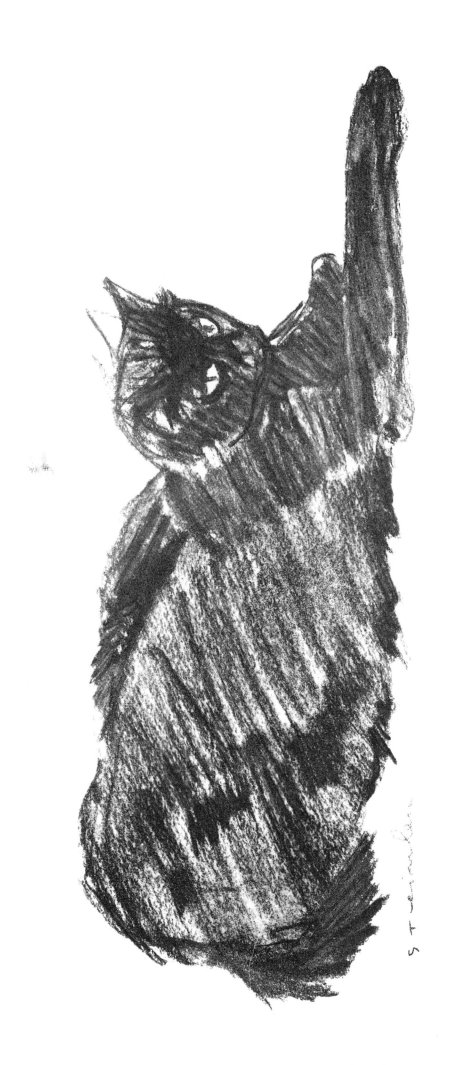

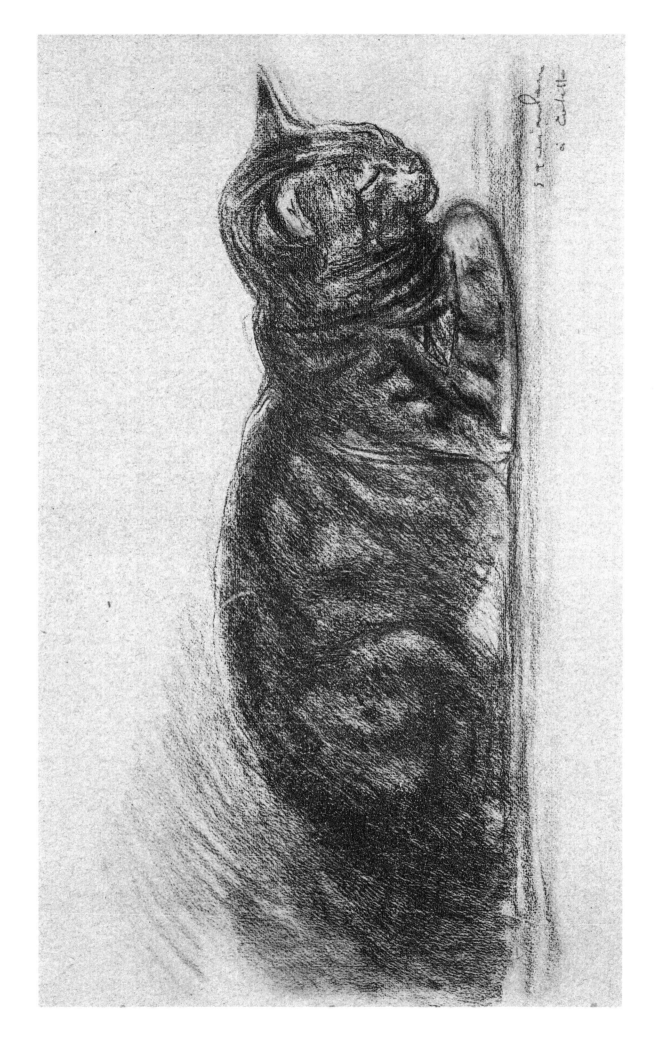

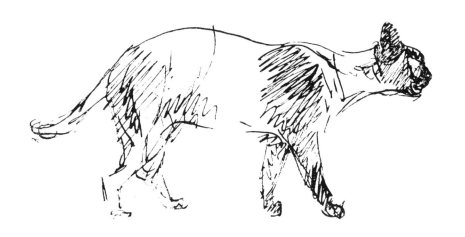
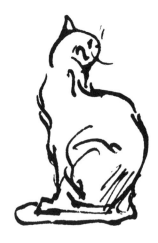
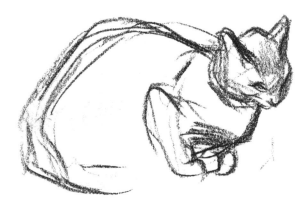
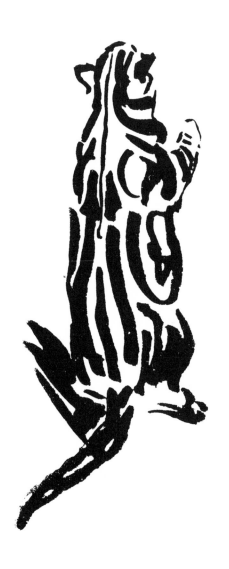
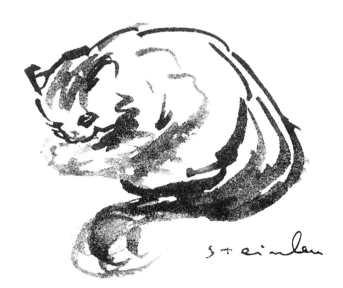

steinlen

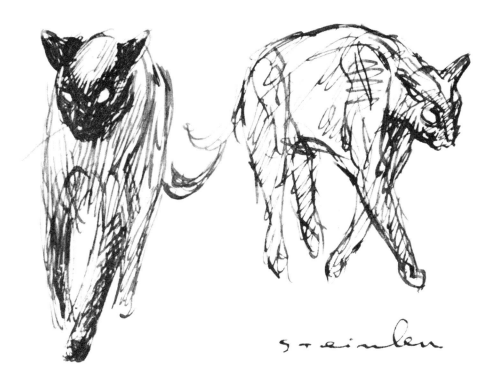

steinlen

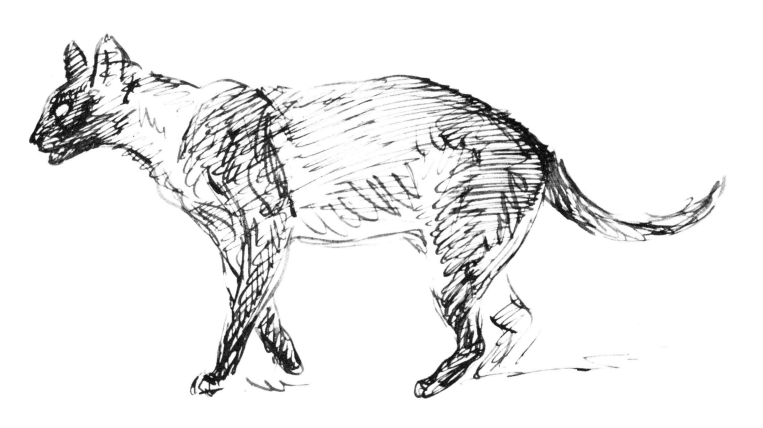

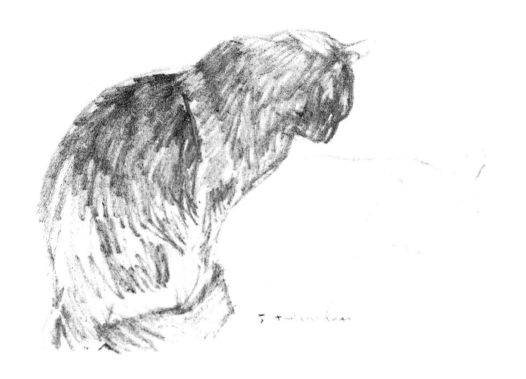

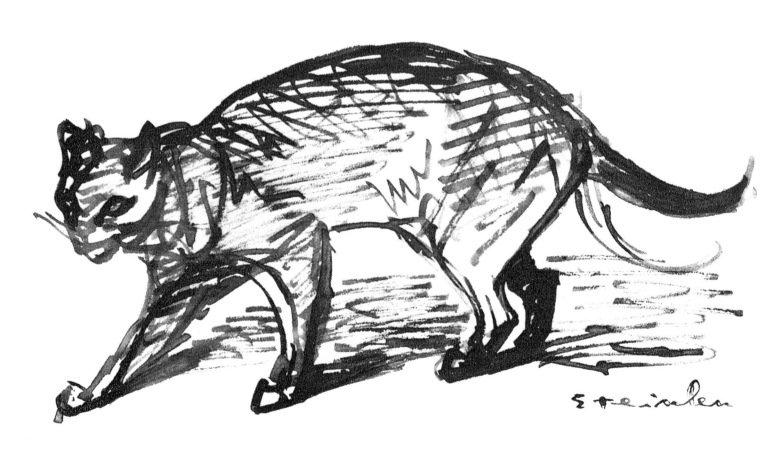

16

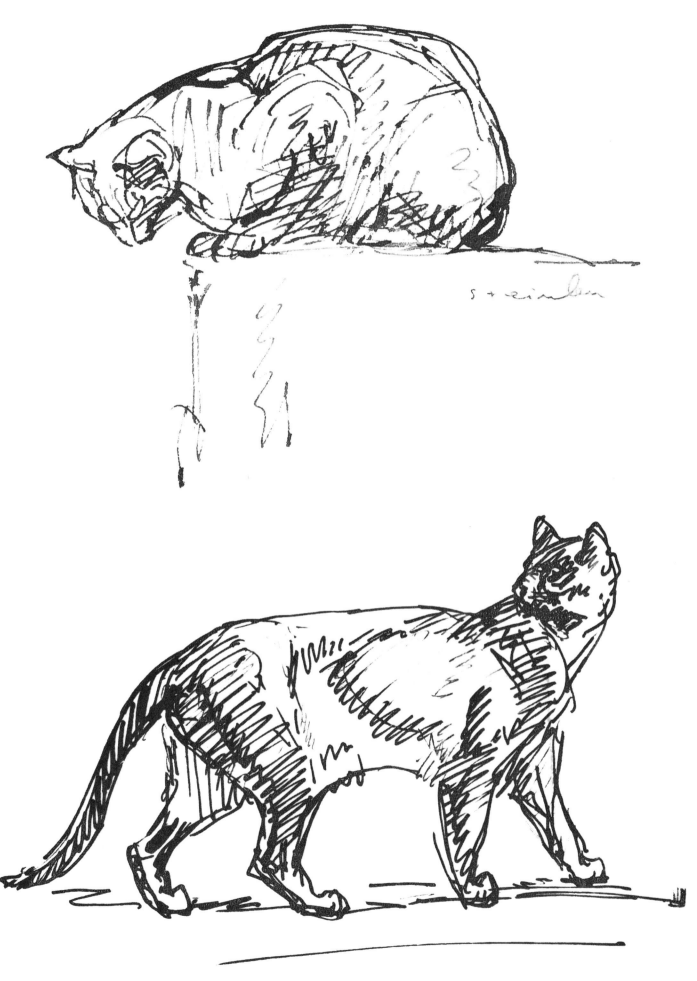

Steinlen

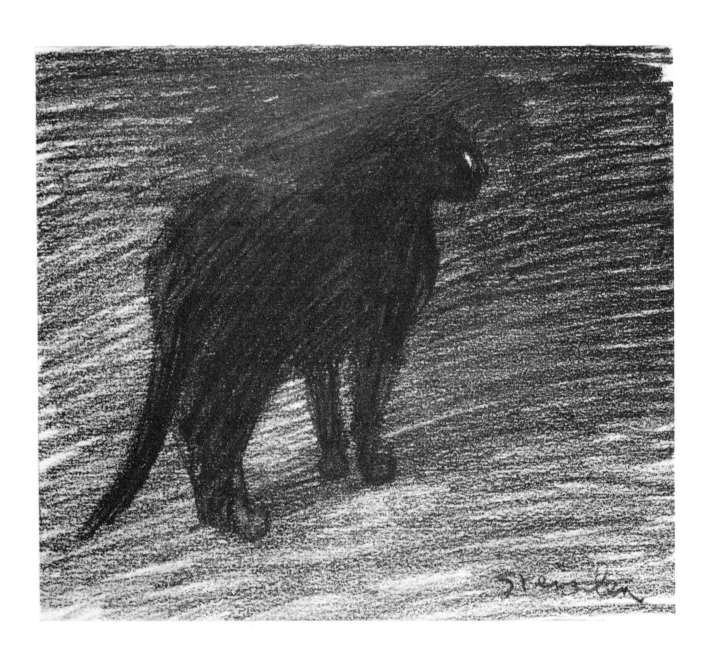

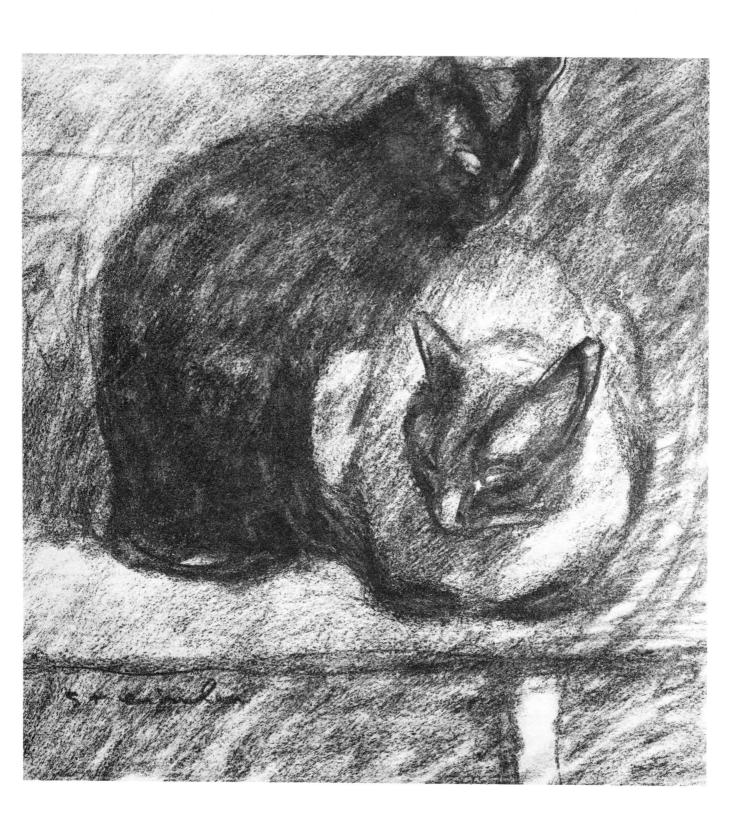

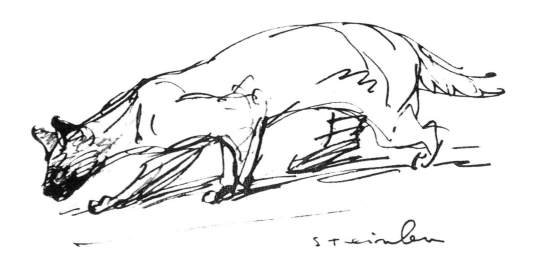

Steinlen

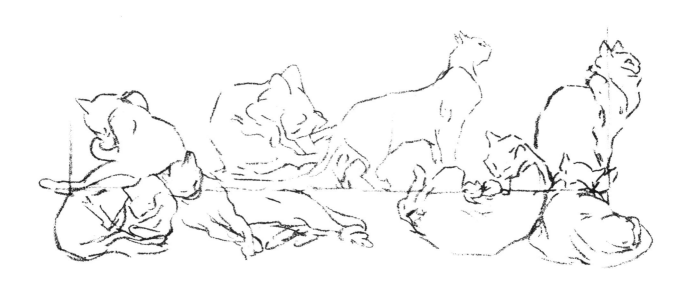

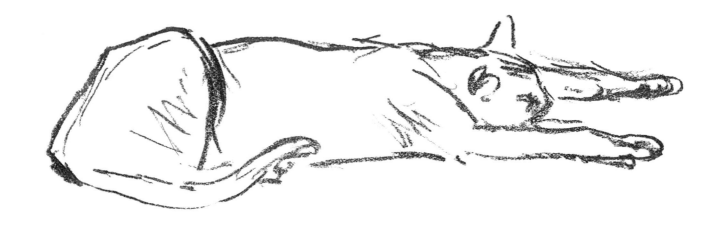

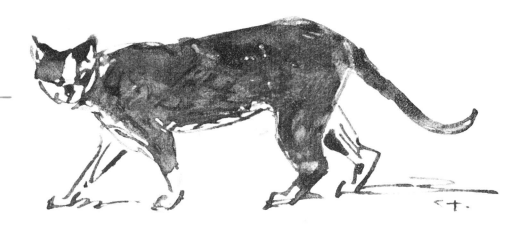

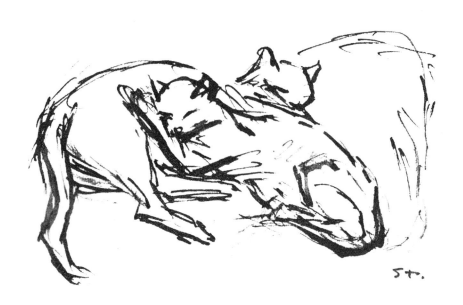

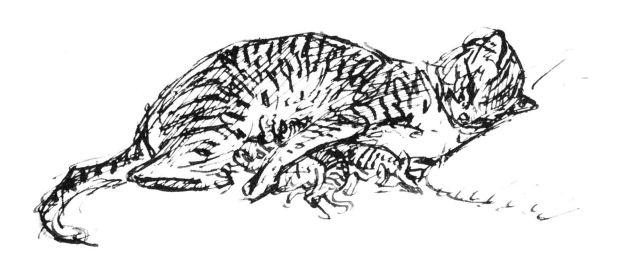

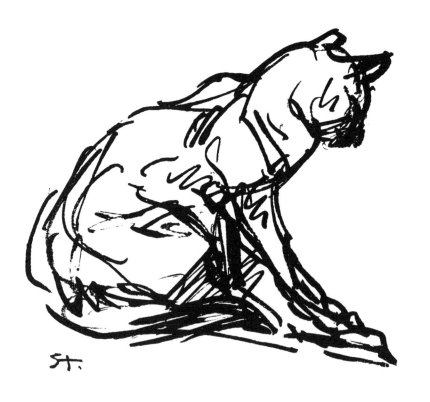
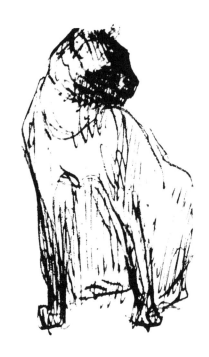
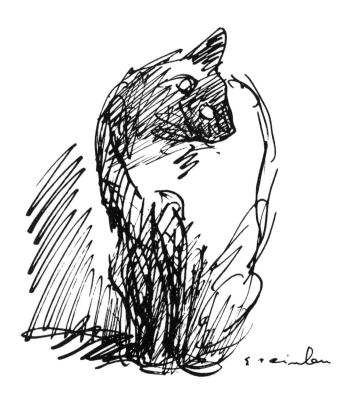
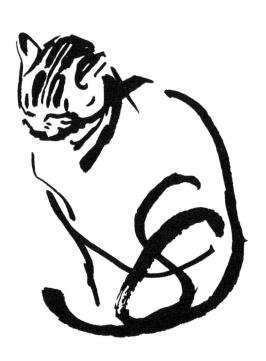

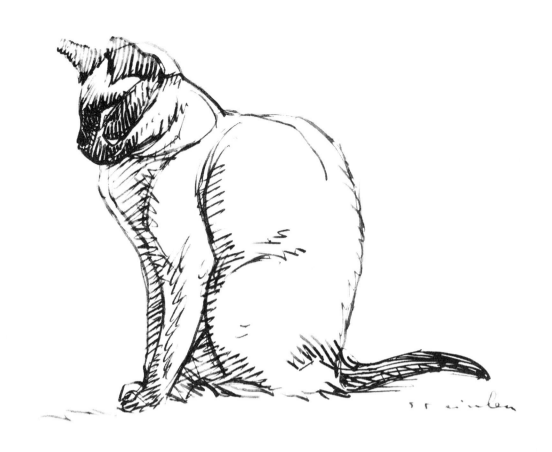

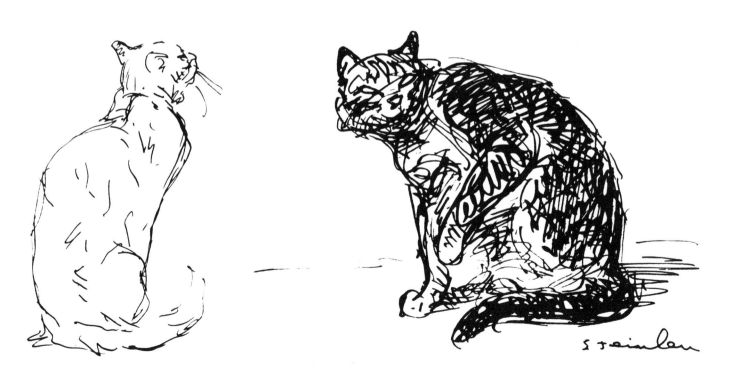

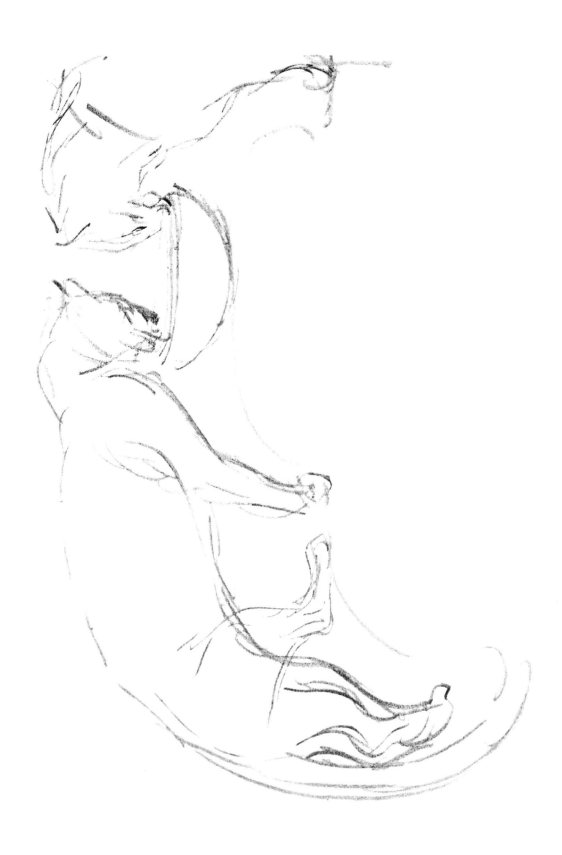

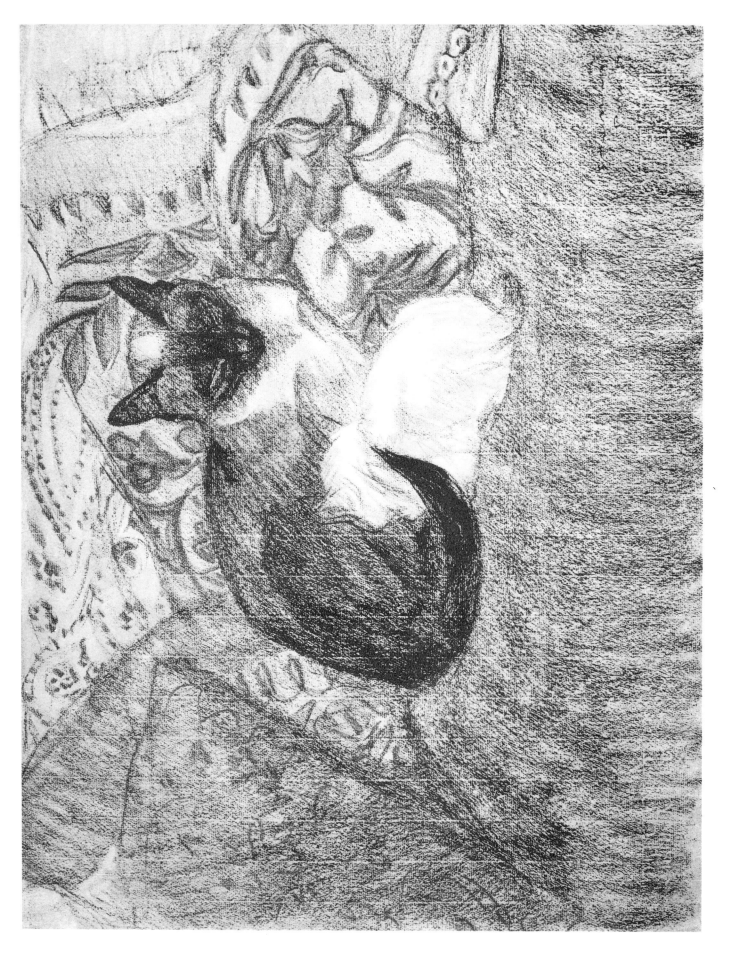

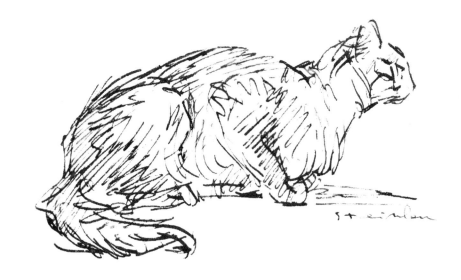

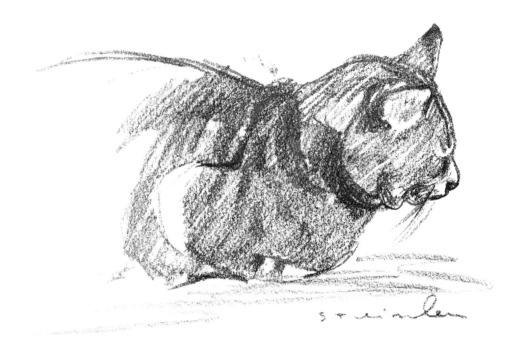

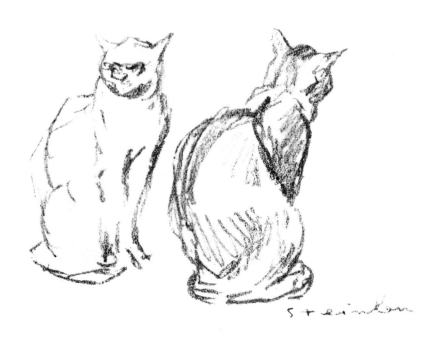

Steinlen

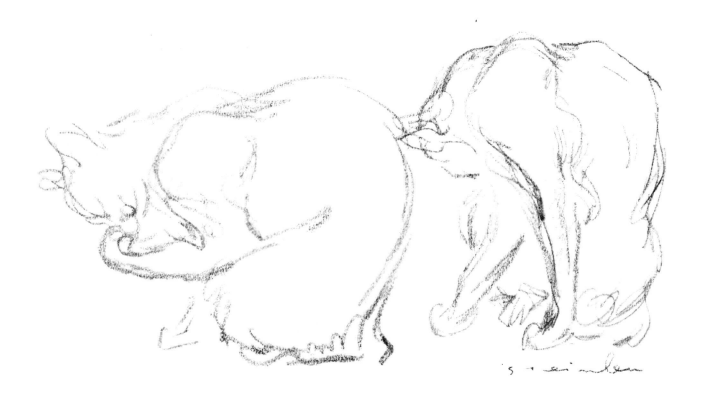

Steinlen

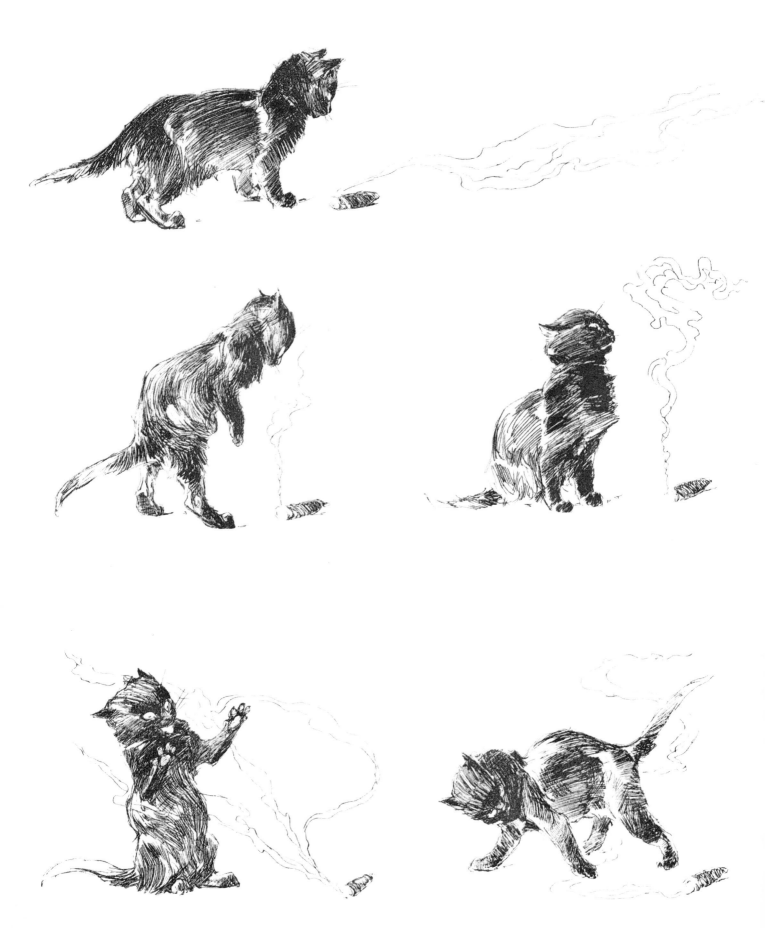

It Burns!

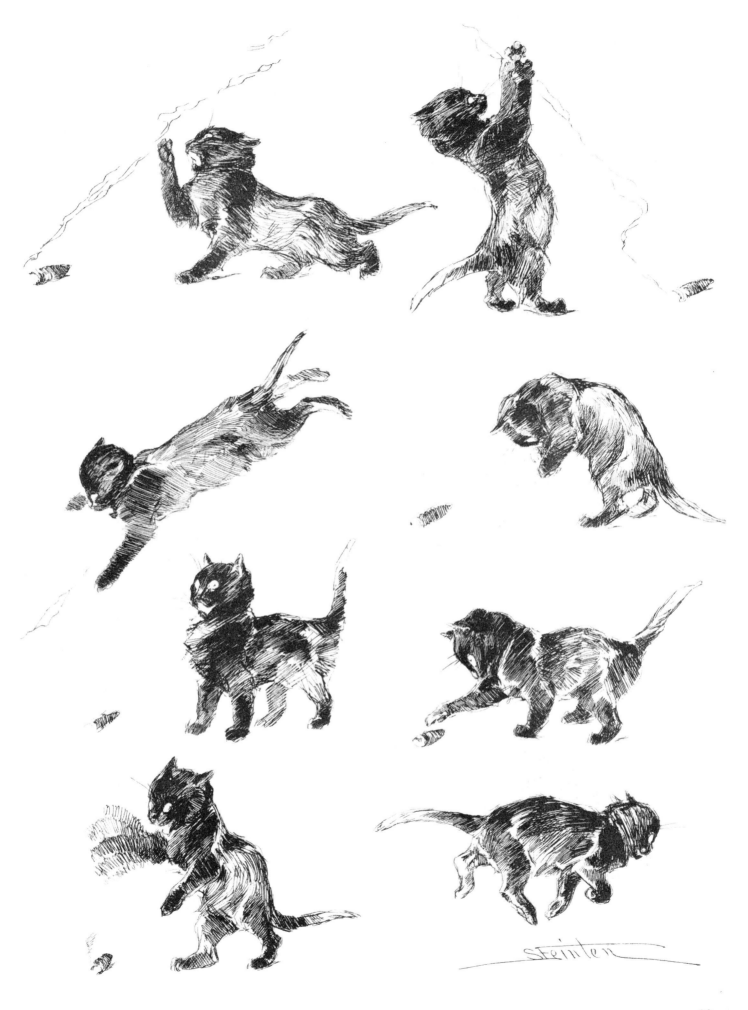

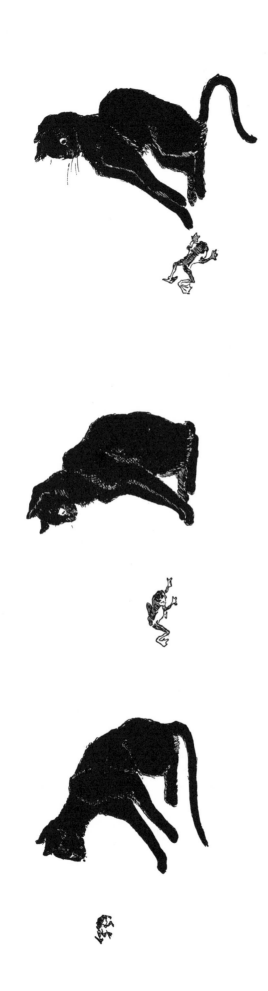
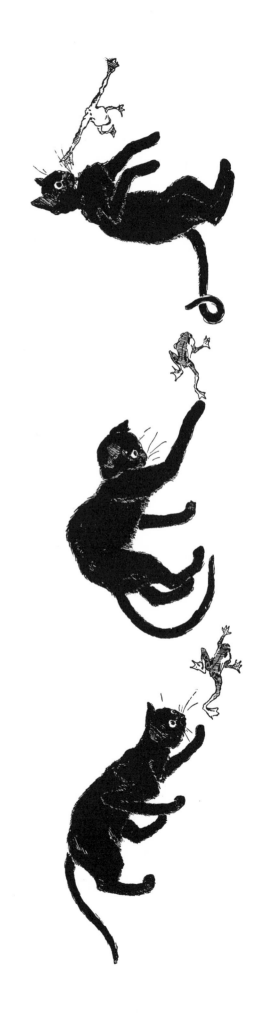

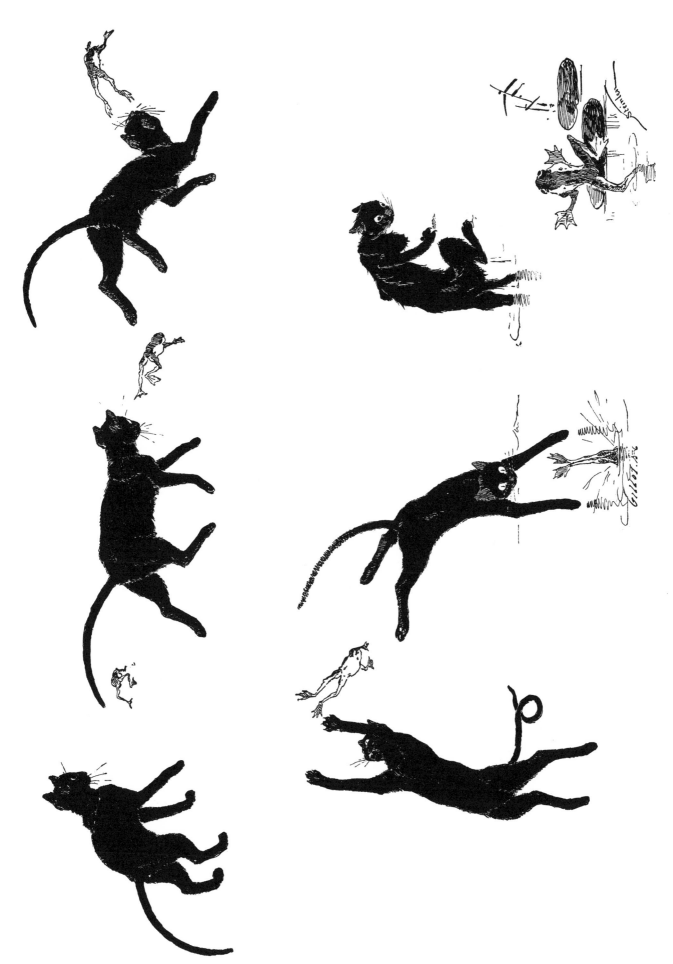

The Cat and the Frog

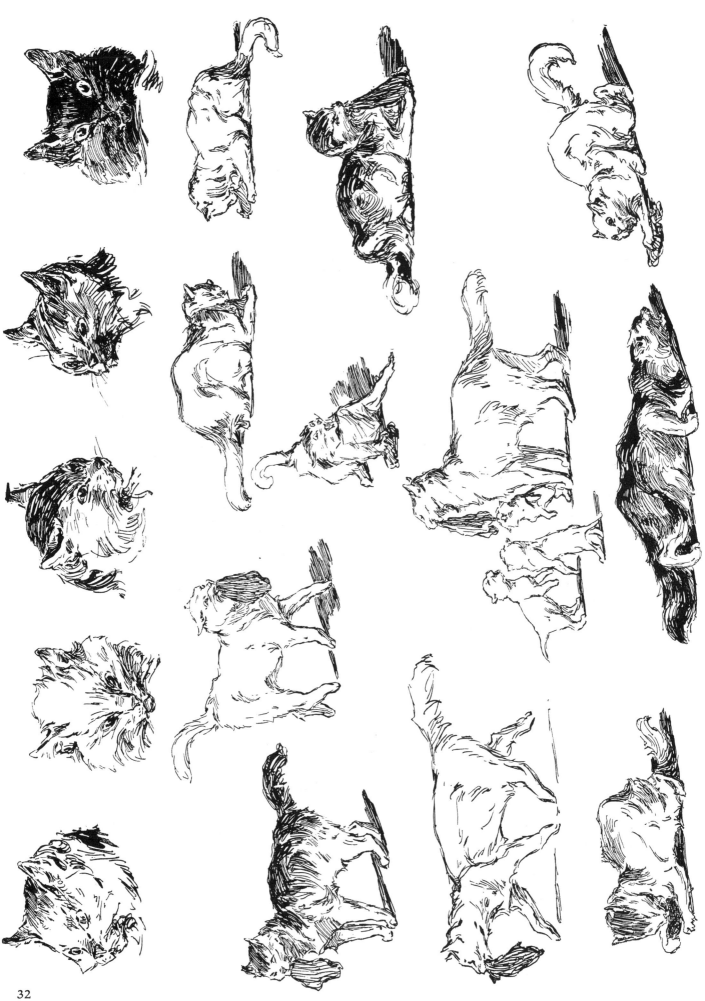

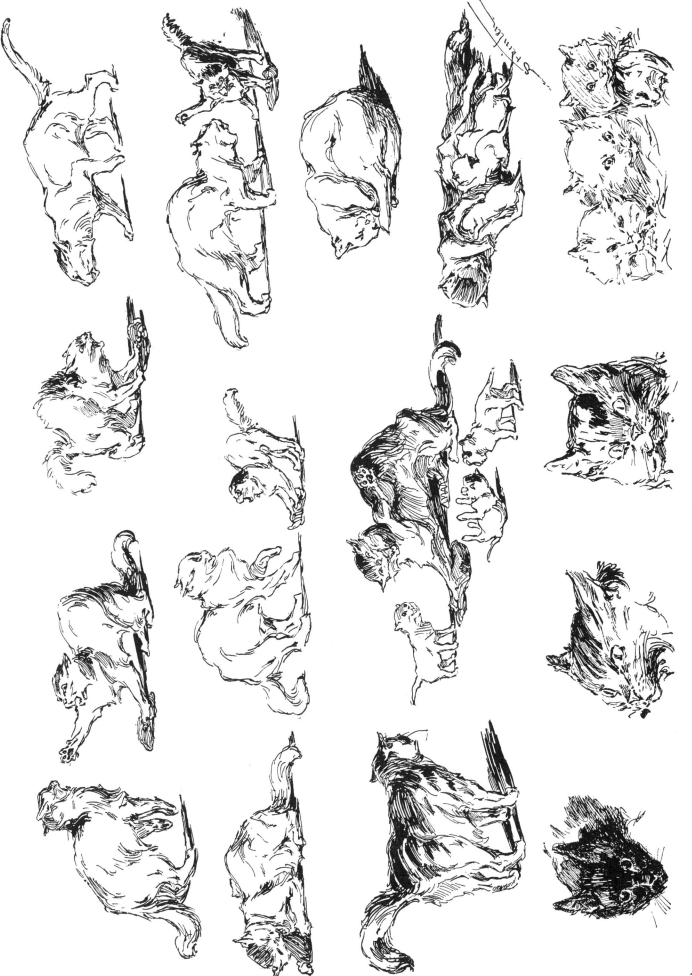

Meows

33

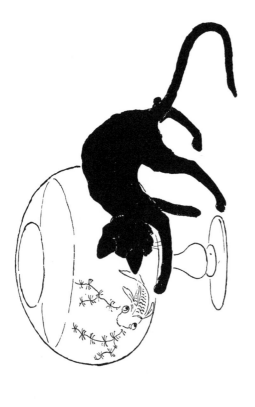

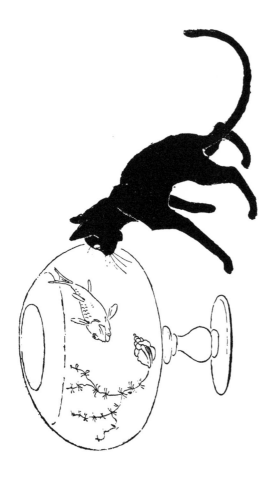

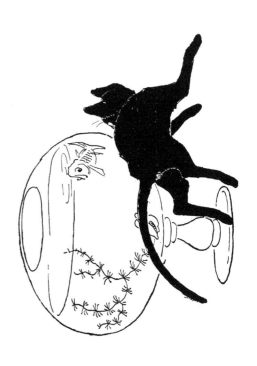

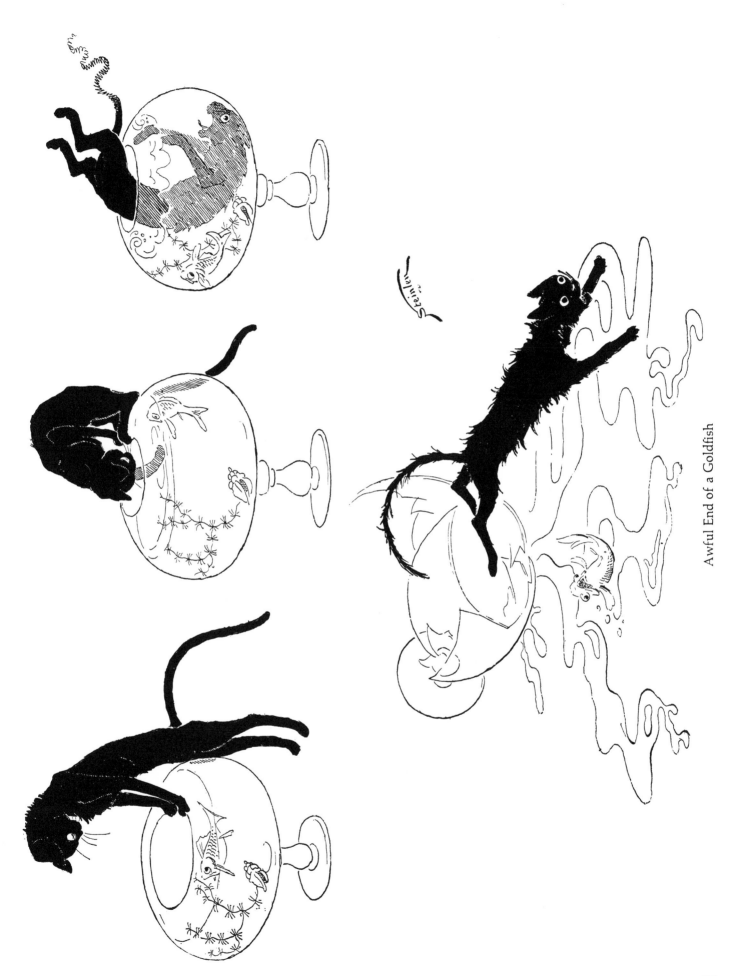

Awful End of a Goldfish

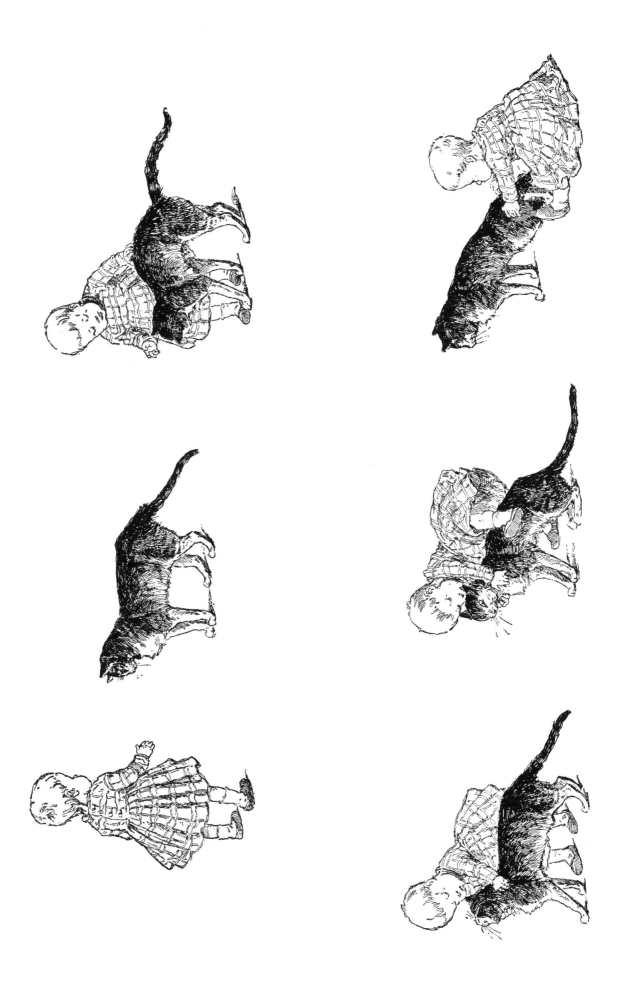

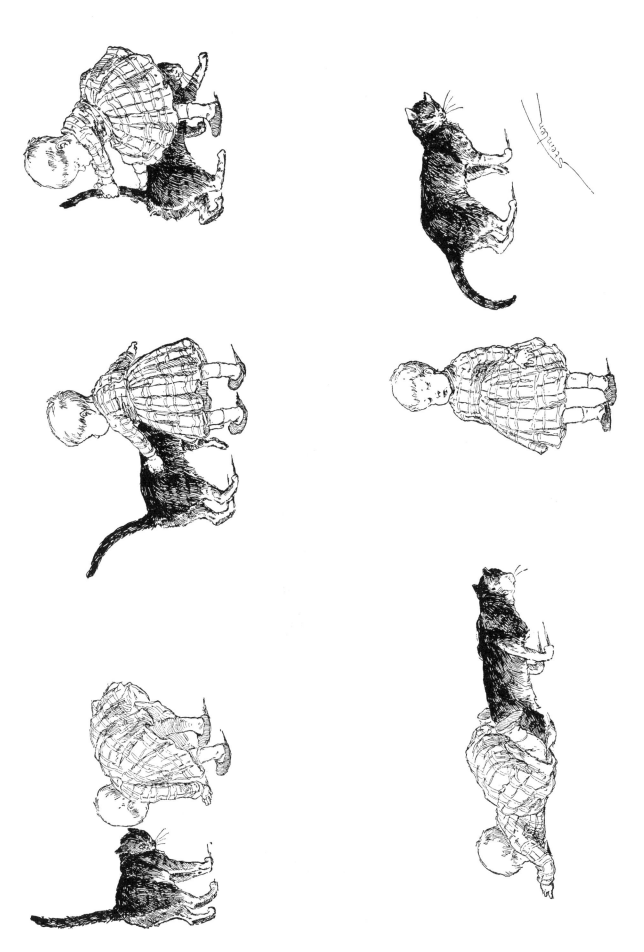

Bad Horsy

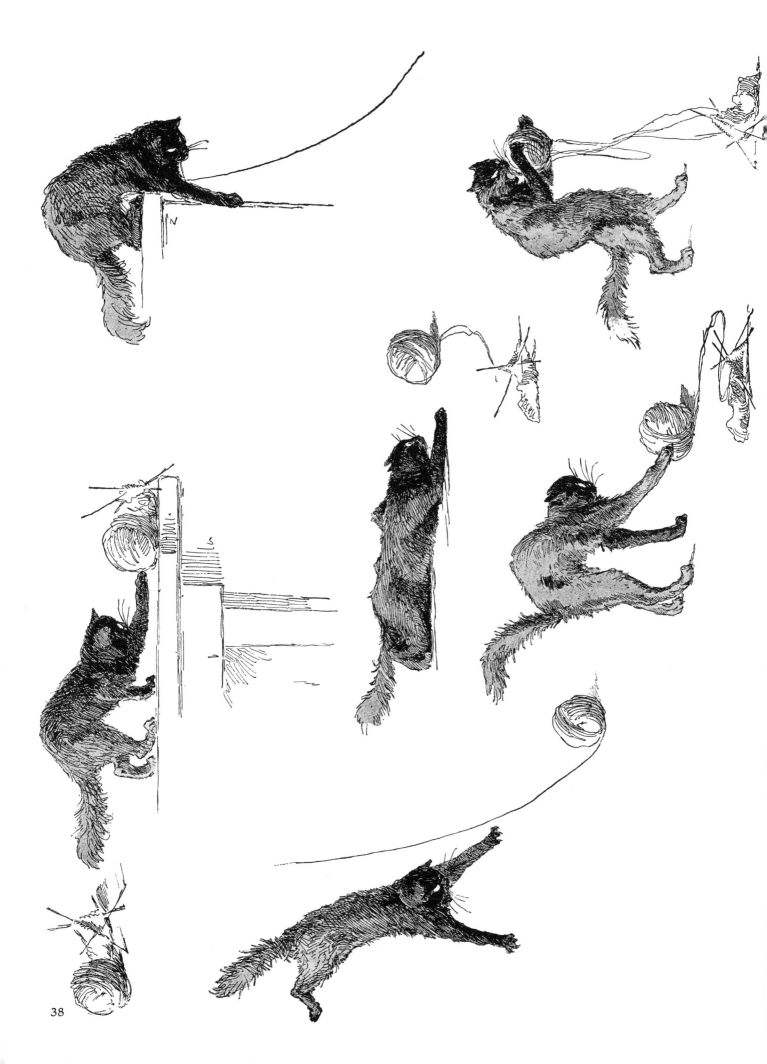

Steinlen

The Ball of Yarn

39

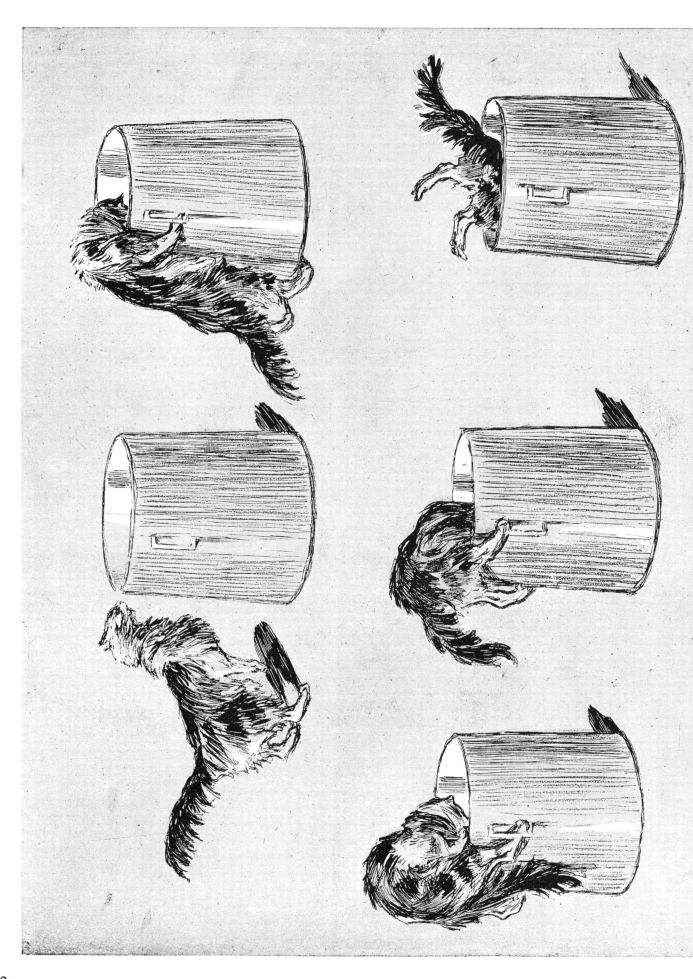

40

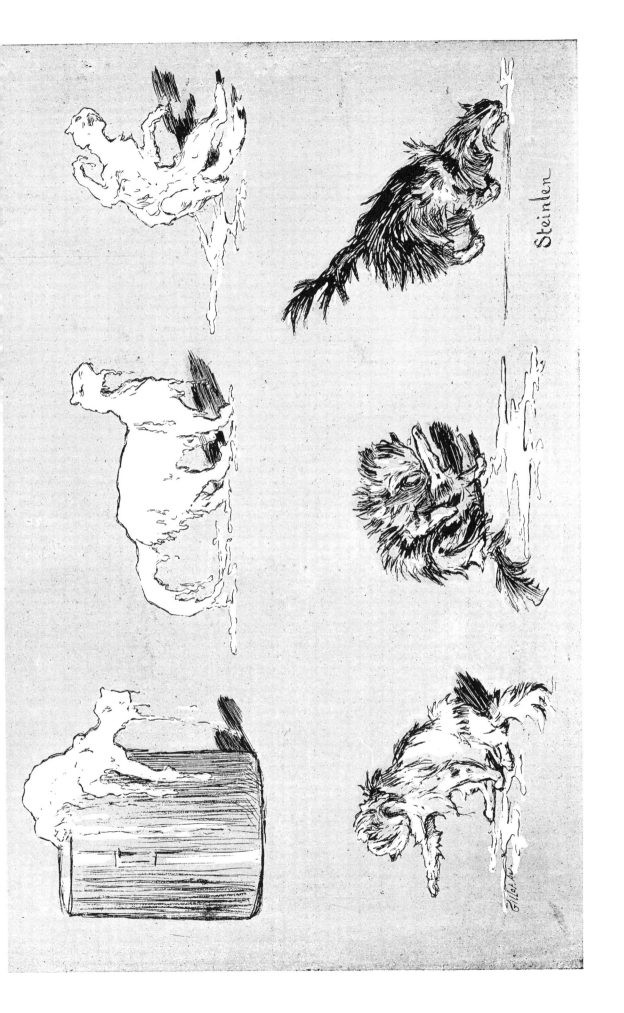

Steinlen

A Result of Greediness

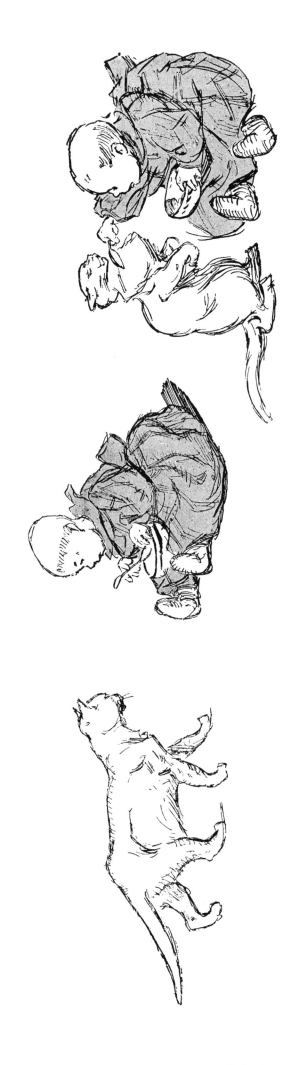
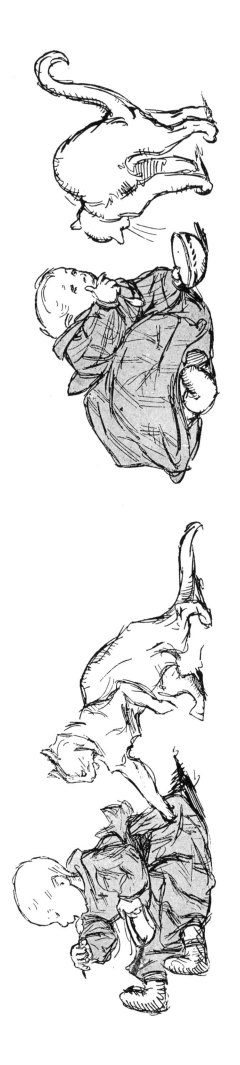

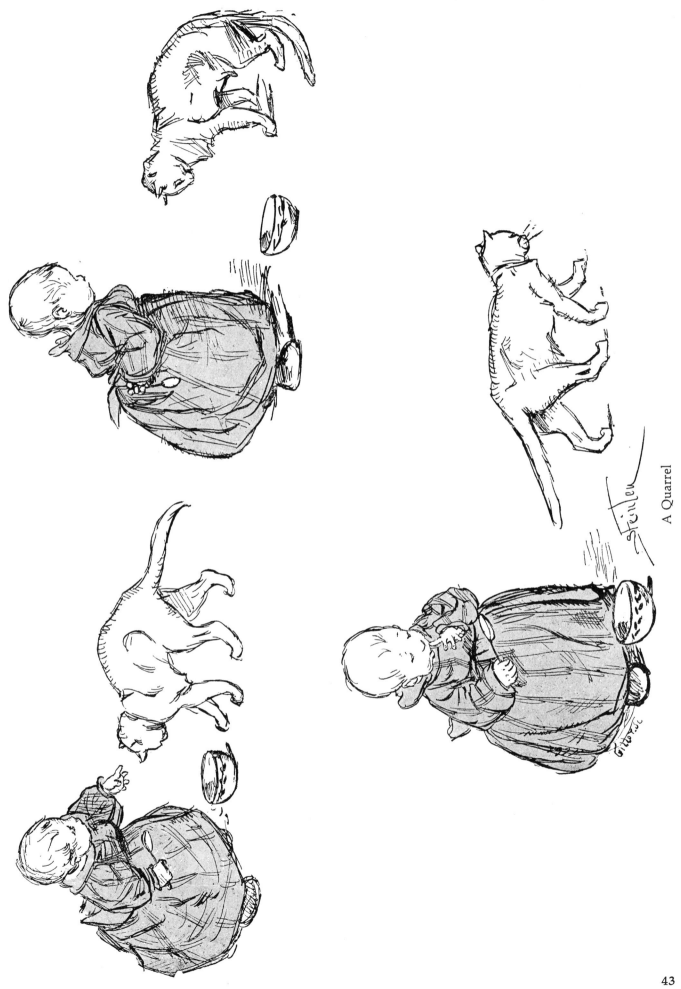

A Quarrel

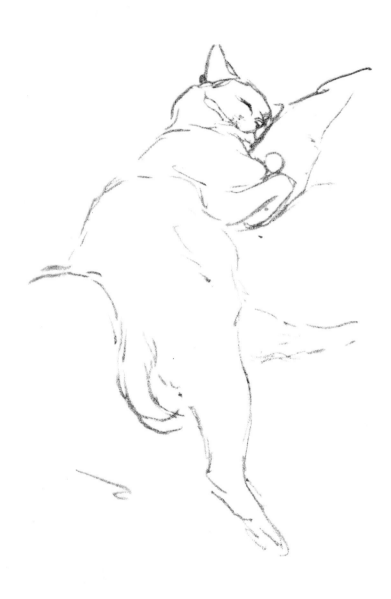